Victorian Foliage Designs

James K. Colling

D1616552

Dover Publications, Inc.

Mineola, New York

Bibliographical Note

This Dover edition, first published in 2003, is a new selection of plates from *Art Foliage: For Sculpture and Decoration*, originally published in London by the author in 1865.

DOVER *Pictorial Archive* SERIES

Library of Congress Cataloging-in-Publication Data

Colling, James Kellaway.
 [Art foliage. Selections]
 Victorian foliage designs / James K. Colling.— Dover ed.
 p. cm. — (Dover pictorial archive series)
 "First published in 2003, a selection of plates from Art foliage, originally published in London by the author in 1865."
 ISBN 0-486-42742-0 (pbk.)
 1. Decoration and ornament—Plant forms. 2. Decoration and ornament—Victorian style. 3. Decoration and ornament, Architectural. I. Title. II. Series.

NK1565.C72 2003
729'.5—dc21

2003043780

Manufactured in the United States of America
Dover Publications, Inc., 31 East 2nd Street, Mineola, N.Y. 11501

NOTE

HROUGHOUT history, decorative art has been deeply influenced by the myriad patterns and designs appearing in nature. Whether in art or architecture, the pleasing geometry and aesthetic value of flowers, fruit, and foliage offer a charming touch to the finished piece, with compositions that can be as simple or intricate as the artist desires.

James Kellaway Colling (c. 1816-1905) was an English architect and a diligent lifelong student of architectural design and engineering, including decorative ornamentation. His work was greatly influenced by the distinct styles found in other cultures and past eras, as well as by the inspiration derived from the examination of natural objects. A strong critic of the direction of art in his time, which he believed either clung to exact replicas of past styles or "a 'hodge-podge' of all periods," Colling longed for a definitive advancement to mark the artistic age in which he lived. Whatever form this progression would take, Colling was adamant that "the infinity and beauty of nature" should enjoy a prominent position in the styles to come. He supported his theories and writings with elegant and meticulous illustrations of nature-inspired ornamentation and design, a selected variety of which has been reproduced in these pages.

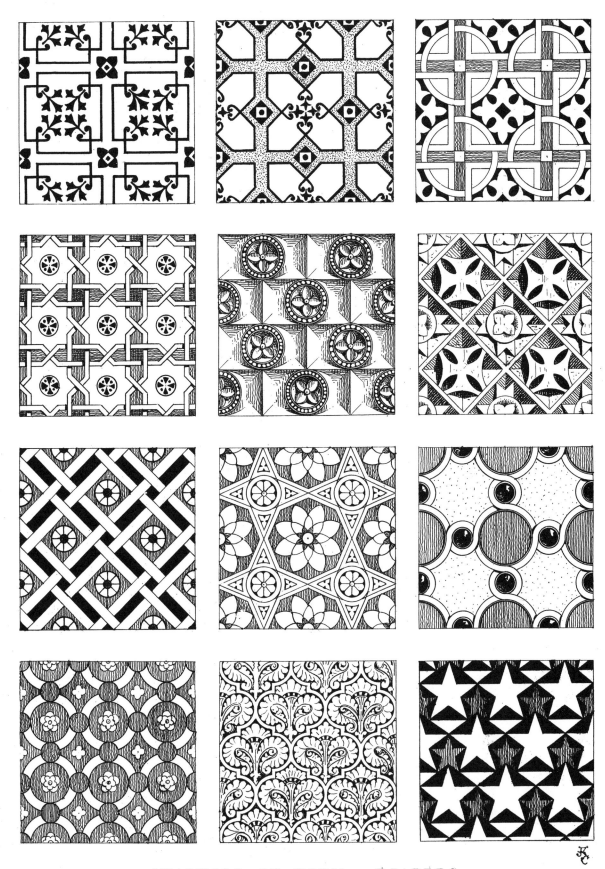

ANALYSIS OF FORM.—DIAPERS.

Plate 1

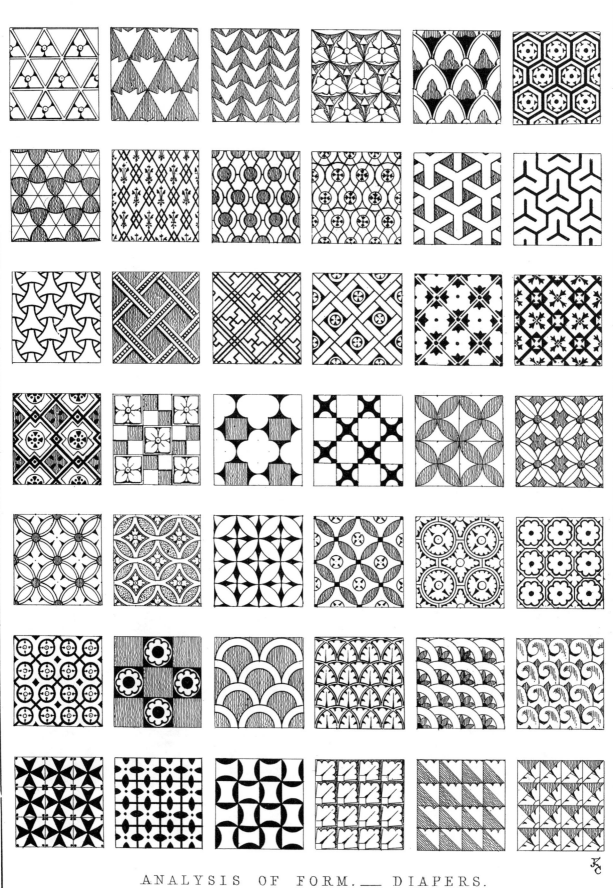

ANALYSIS OF FORM.__ DIAPERS.

Plate 2

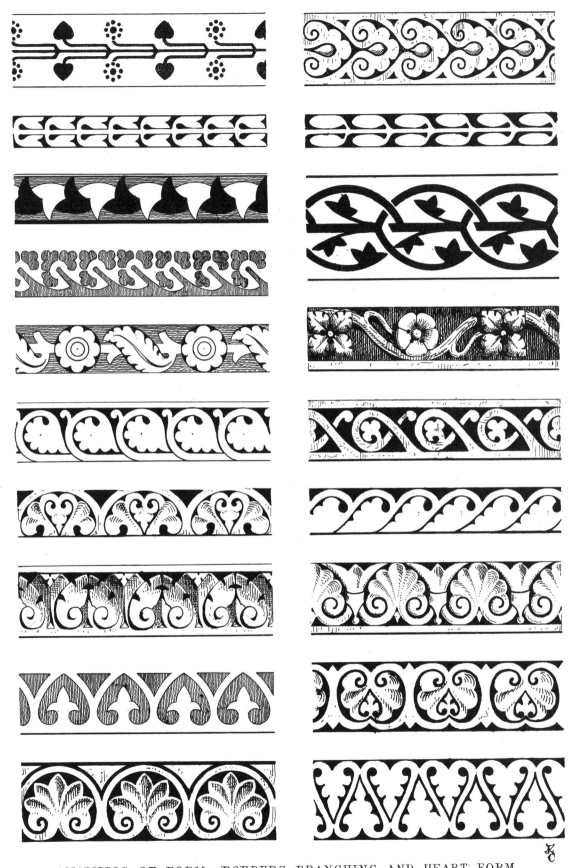

ANALYSIS OF FORM — BORDERS, BRANCHING AND HEART FORM.

Plate 3

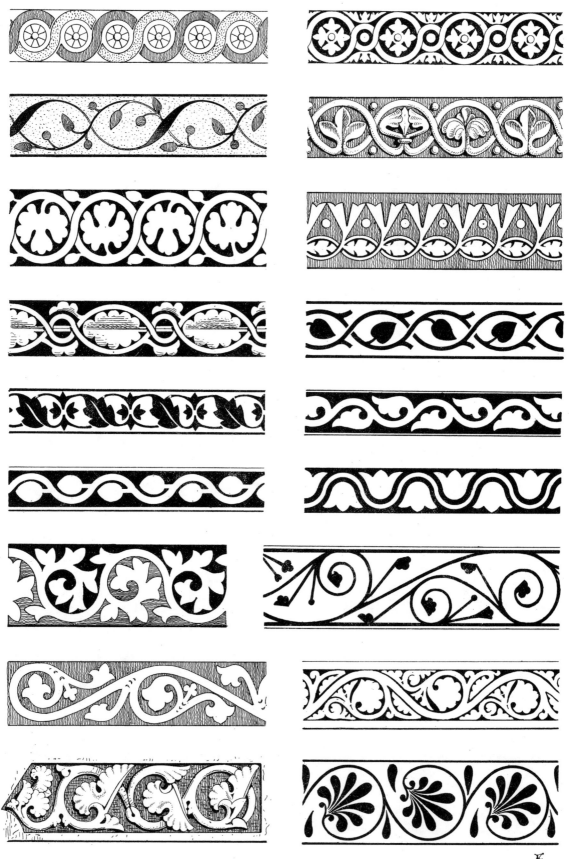

ANALYSIS OF FORM. BORDERS — GUILLOCHE AND WAVE LINE.

Plate 4

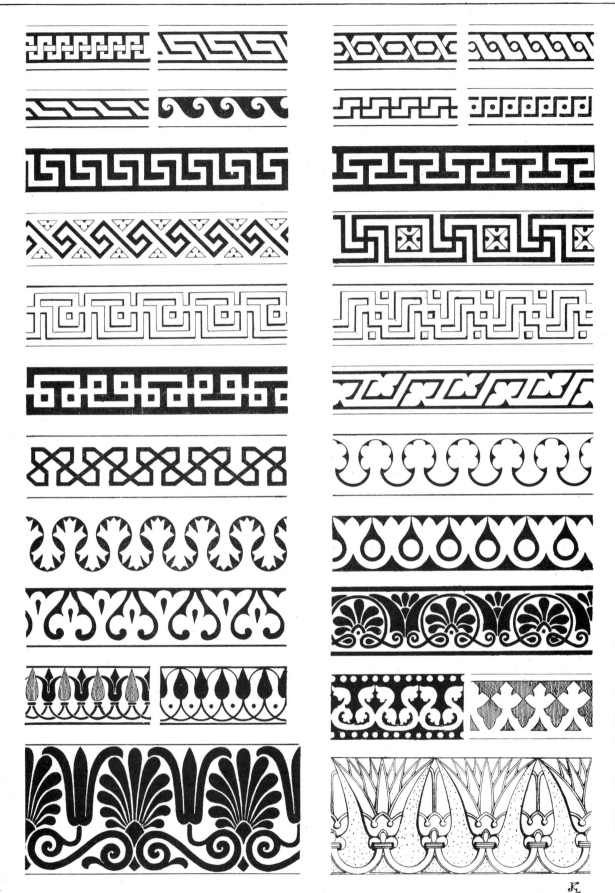

ANALYSIS OF FORM. BORDERS — FRET AND ANTHEMION

Plate 5

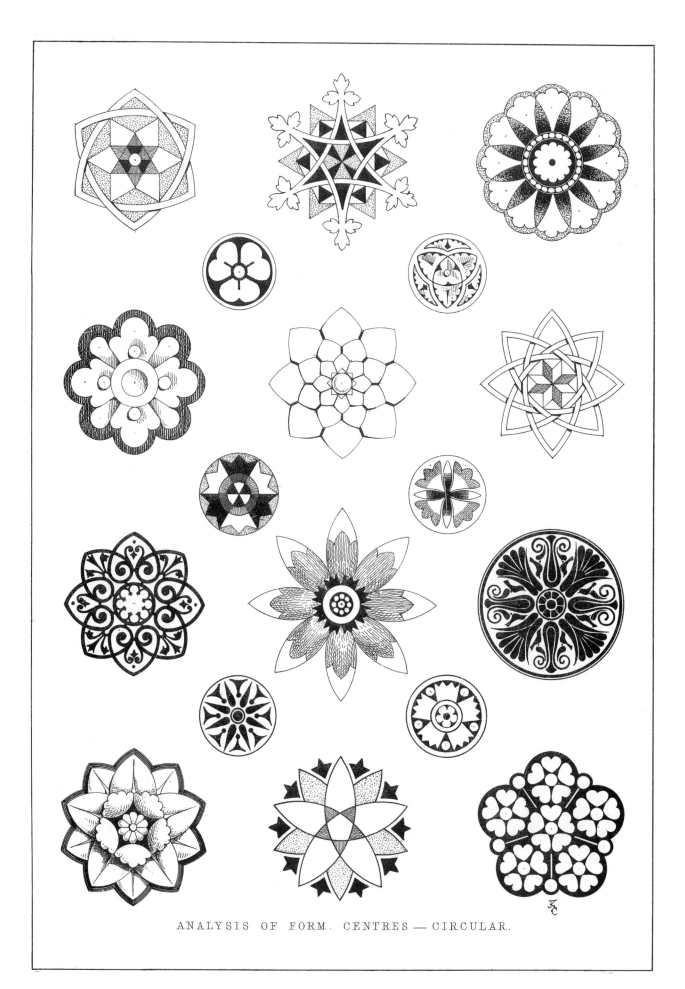

ANALYSIS OF FORM. CENTRES — CIRCULAR.

Plate 6

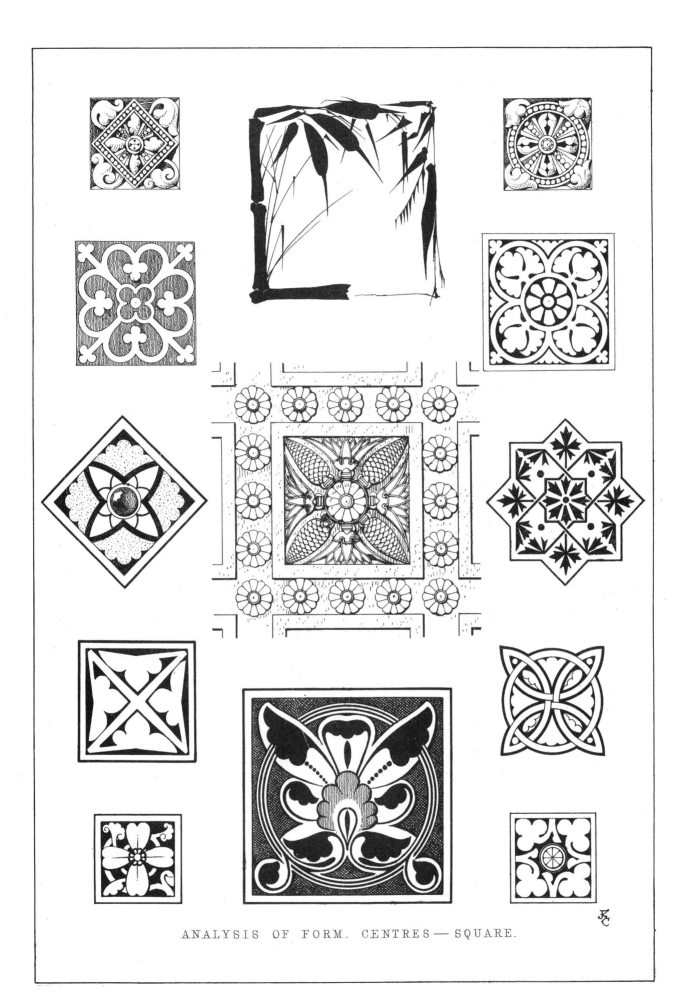

ANALYSIS OF FORM. CENTRES — SQUARE.

Plate 7

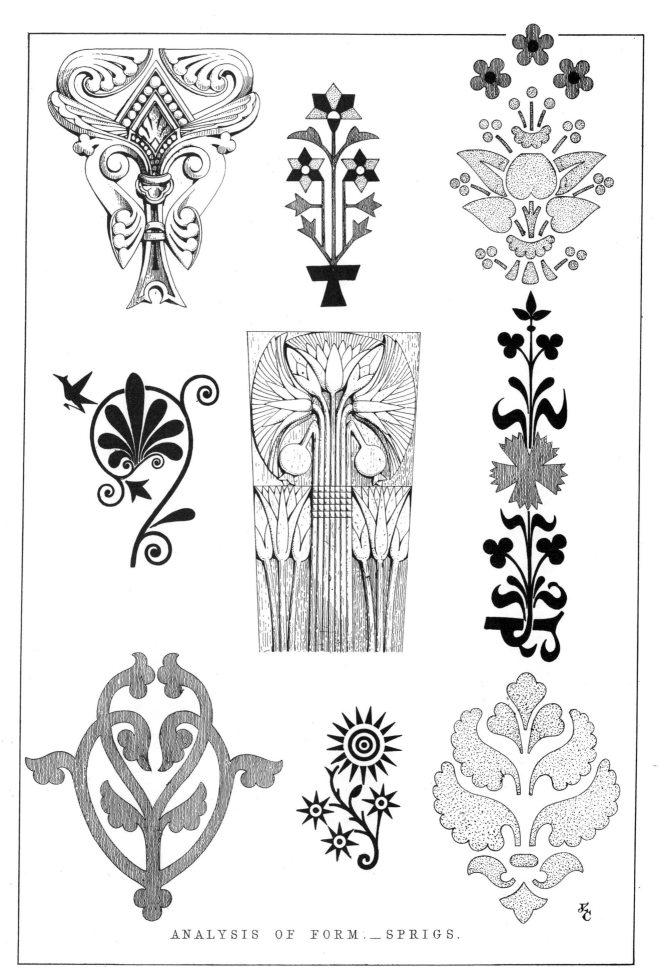

ANALYSIS OF FORM.—SPRIGS.

Plate 8

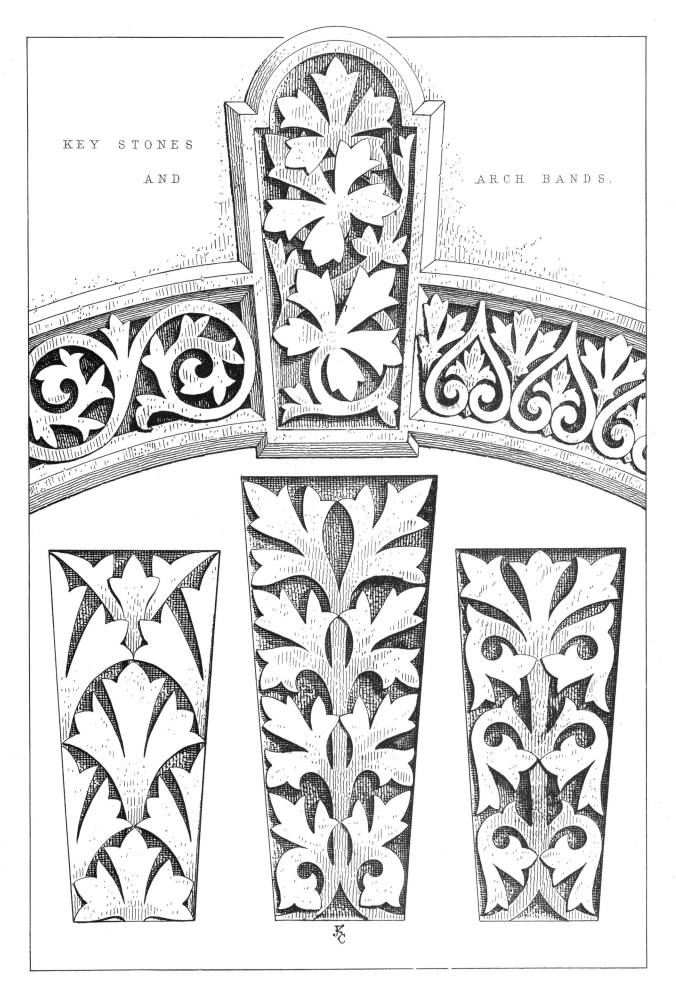

KEY STONES

AND

ARCH BANDS.

Plate 9

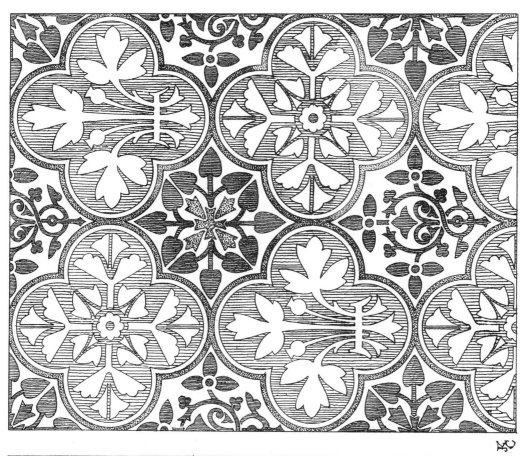

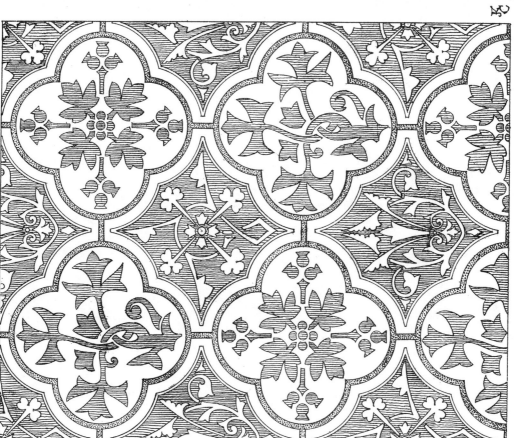

PAPER HANGINGS OR WOVEN FABRICS.

Plate 10

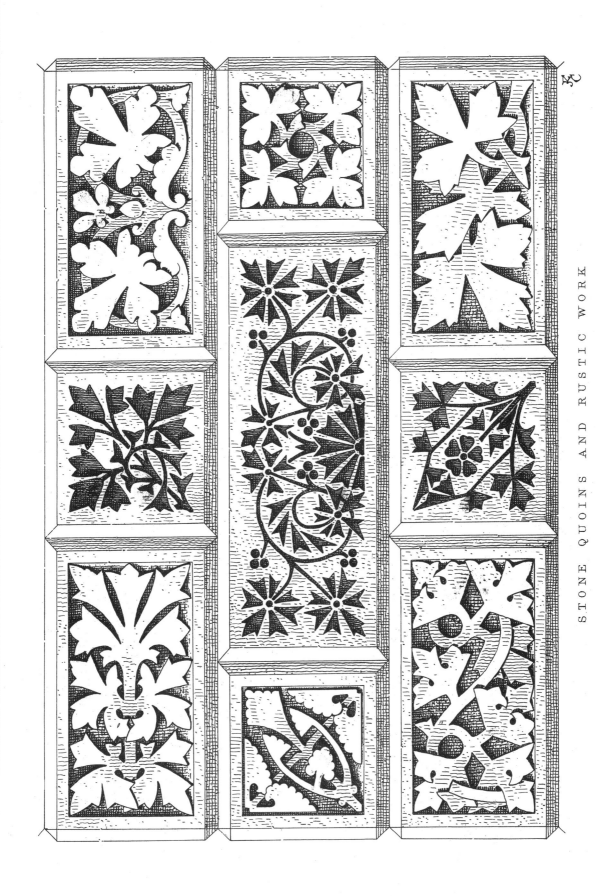

STONE QUOINS AND RUSTIC WORK

Plate 11

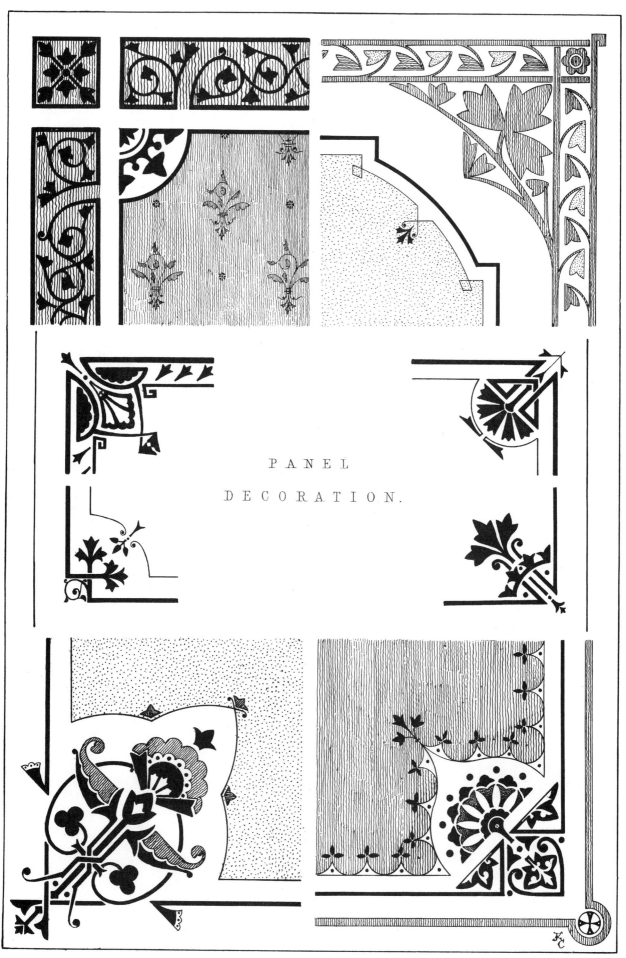

PANEL

DECORATION.

Plate 12

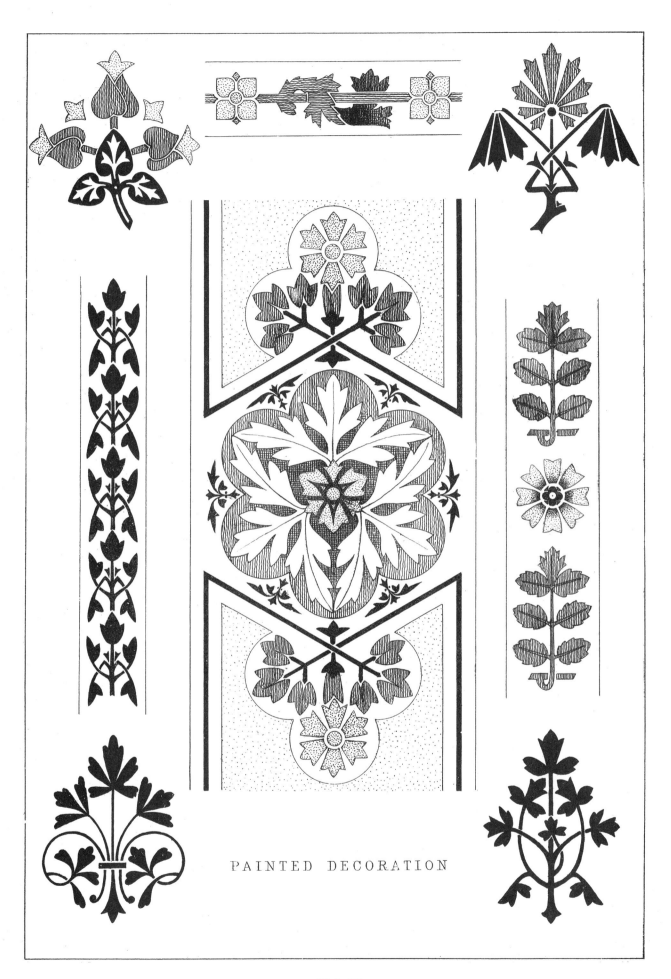

PAINTED DECORATION

Plate 13

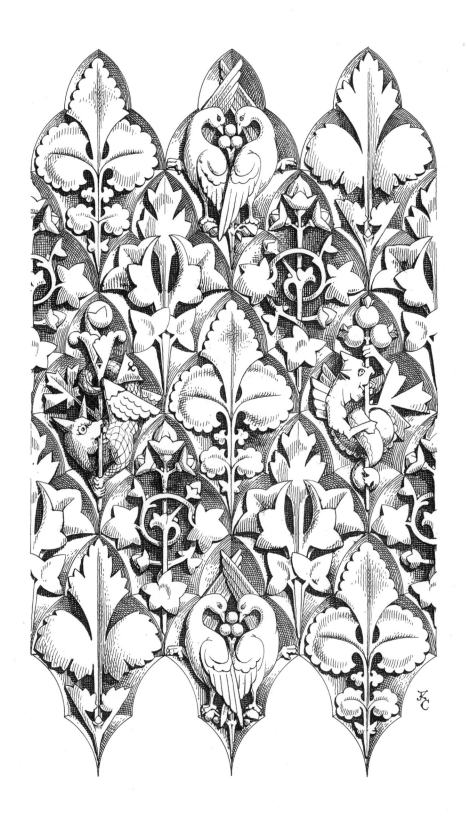

CARVED DIAPERS.

Plate 14

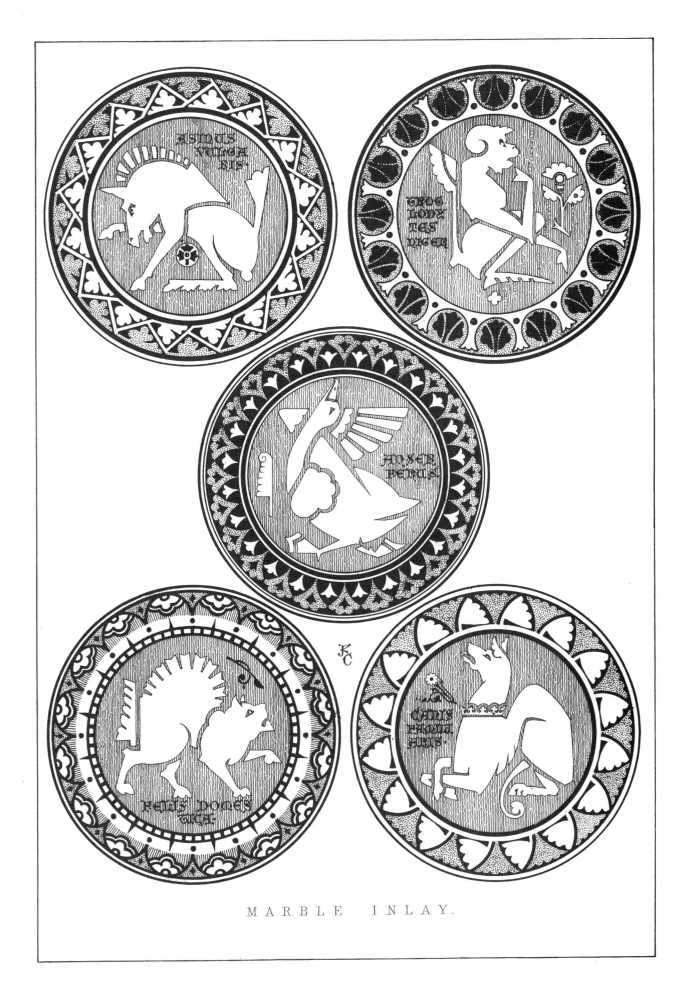

MARBLE INLAY.

Plate 15

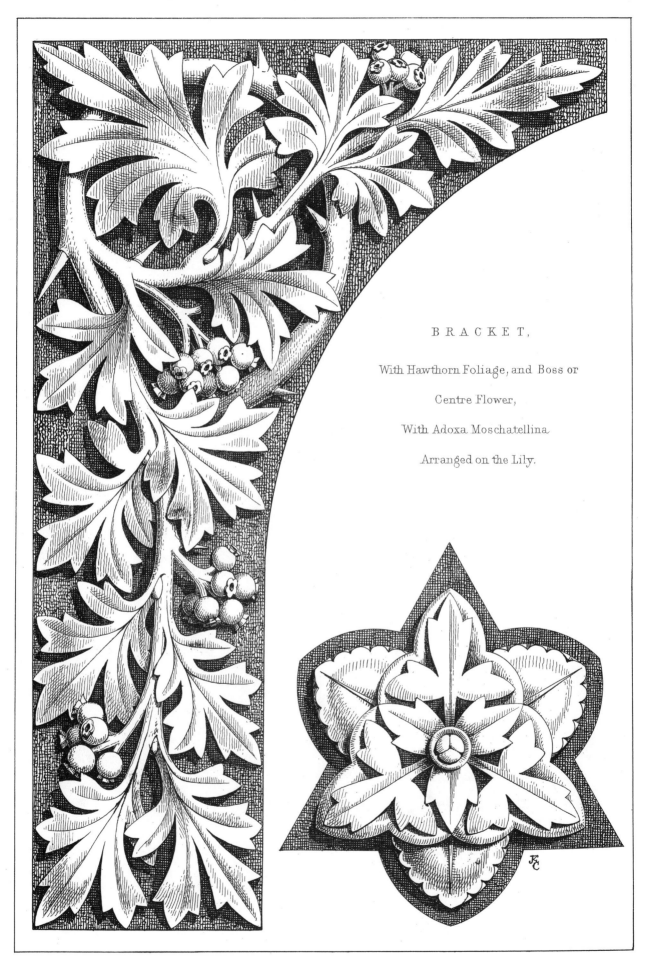

BRACKET,

With Hawthorn Foliage, and Boss or

Centre Flower,

With Adoxa Moschatellina

Arranged on the Lily.

Plate 16

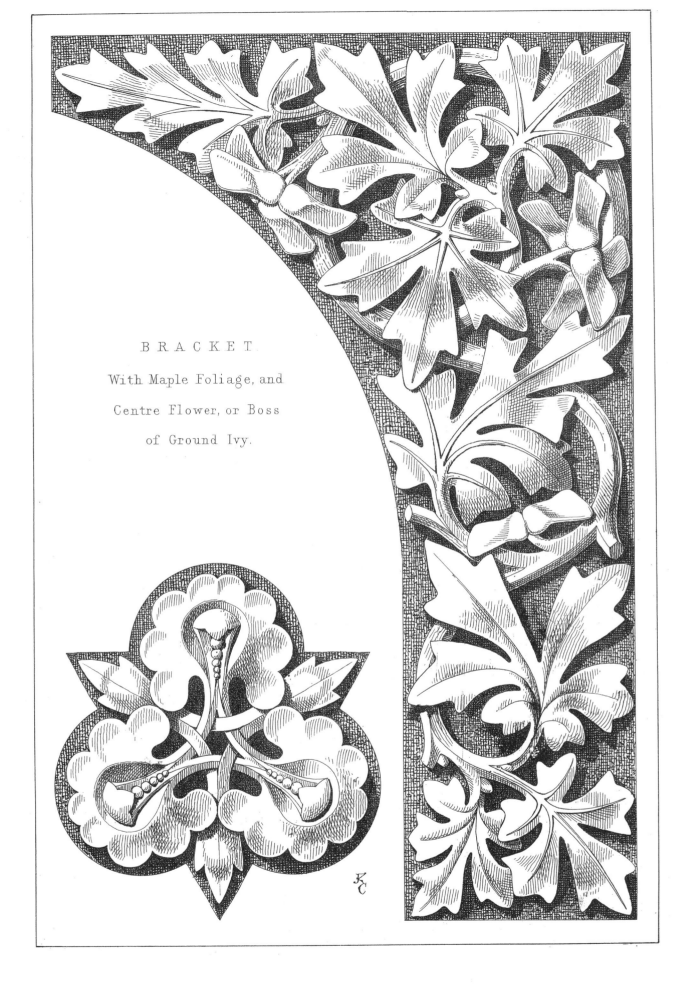

B R A C K E T.

With Maple Foliage, and
Centre Flower, or Boss
of Ground Ivy.

Plate 17

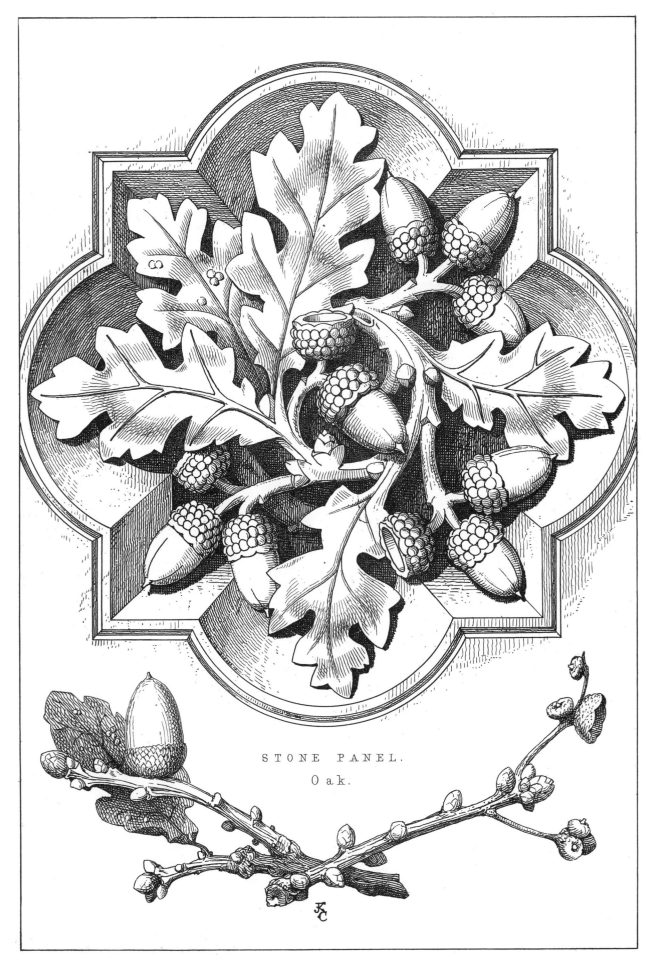

STONE PANEL.

Oak.

Plate 18

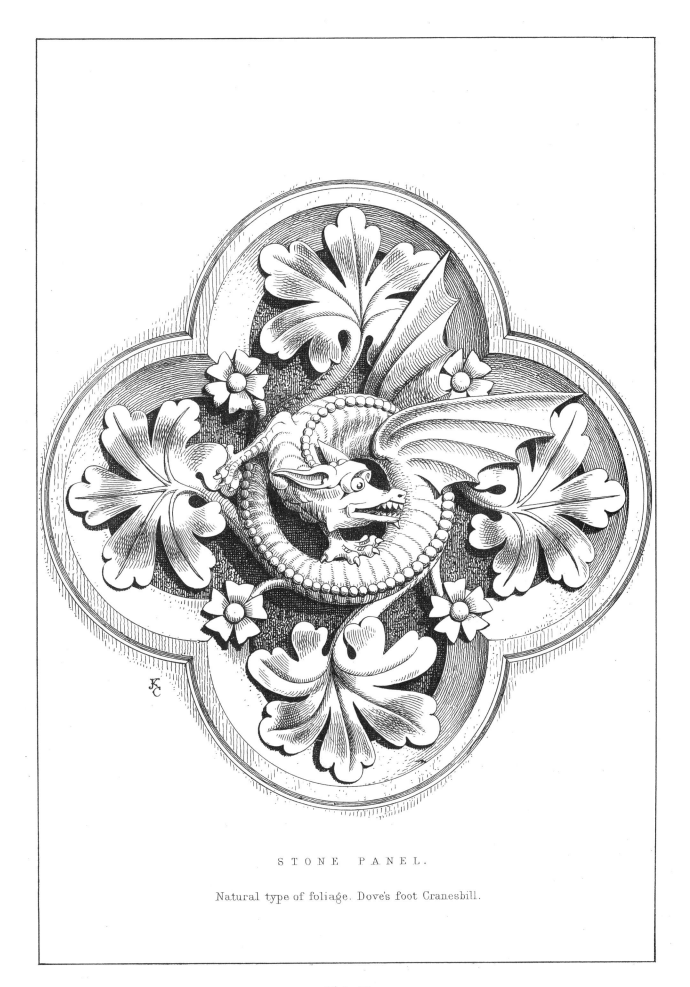

STONE PANEL.

Natural type of foliage. Dove's foot Cranesbill.

Plate 19

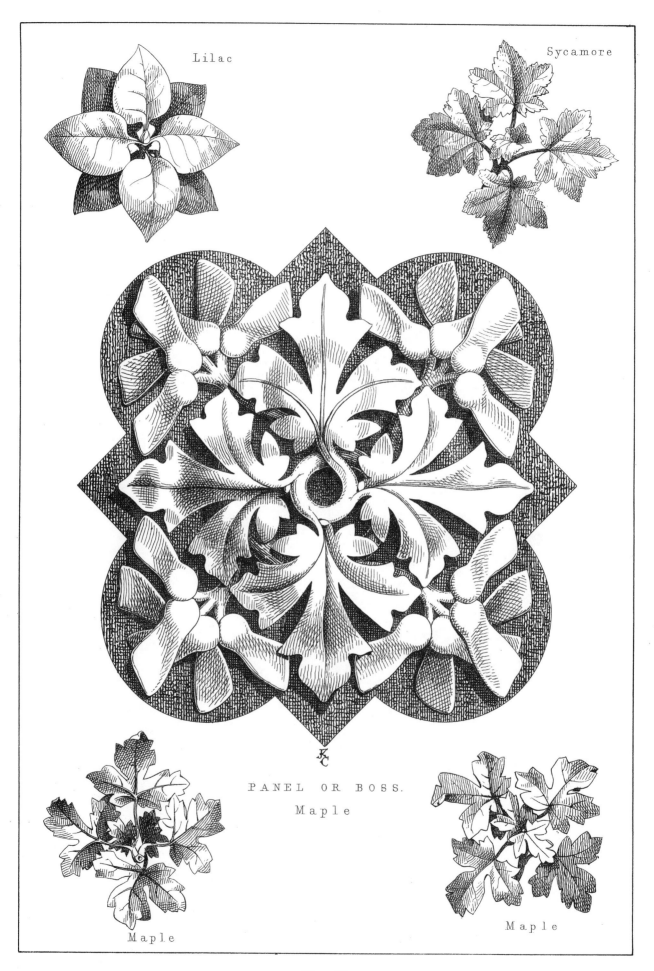

Lilac

Sycamore

PANEL OR BOSS.
Maple

Maple

Maple

Plate 20

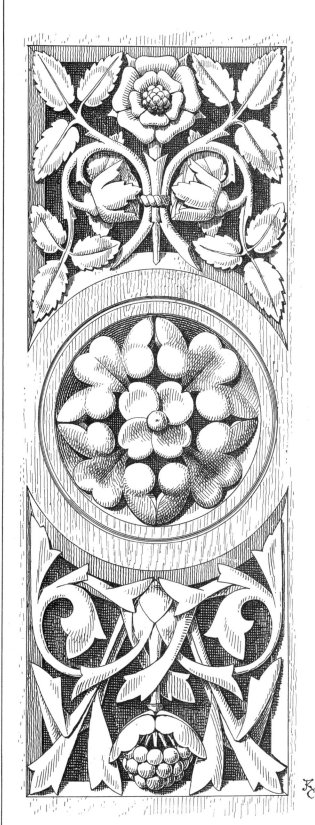
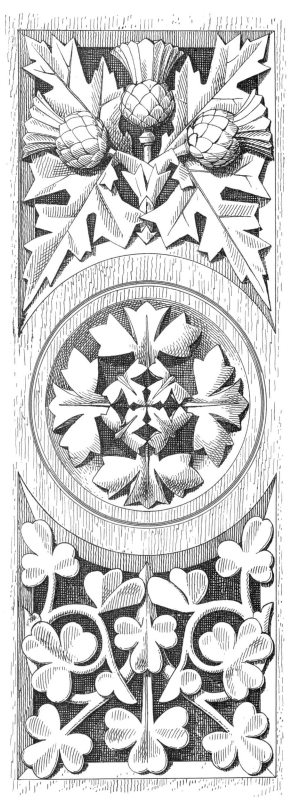

CABINET DOORS WITH NATIONAL EMBLEMS.

Plate 21

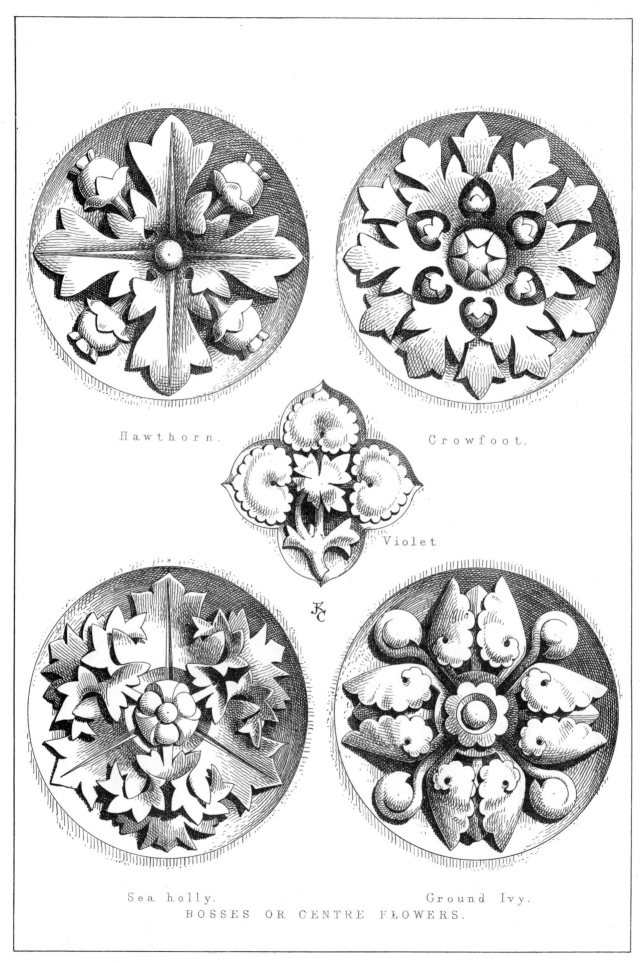

Hawthorn.

Crowfoot.

Violet

Sea holly.

Ground Ivy.

BOSSES OR CENTRE FLOWERS.

Plate 22

Celery-leaved Crowfoot.

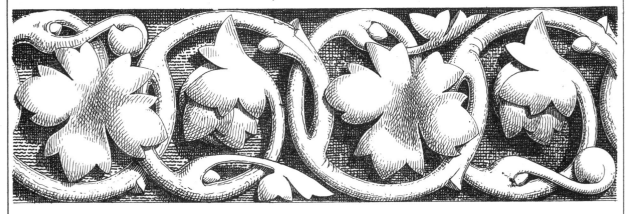

Rose.

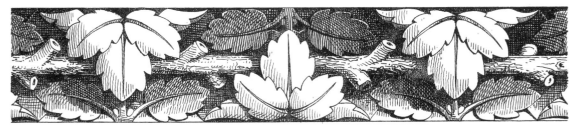

Avens.

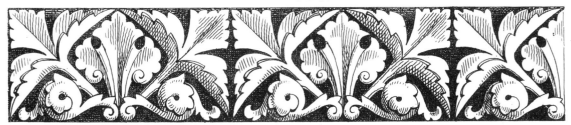

Thistle.

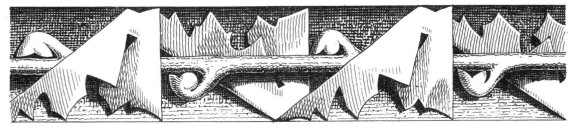

Ivy

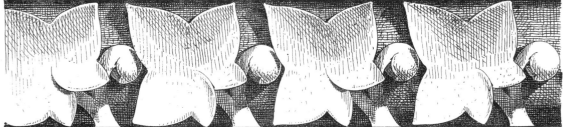

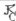

STRING COURSES

Plate 23

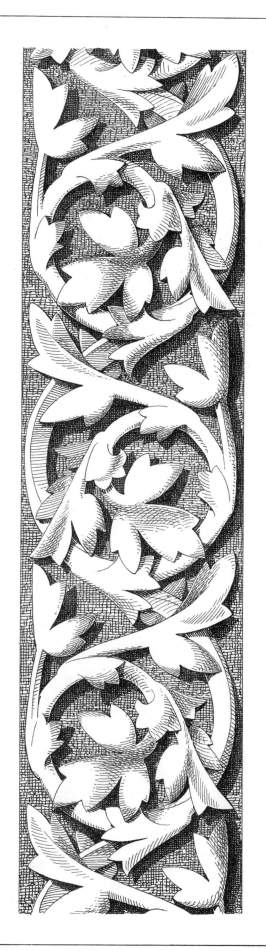
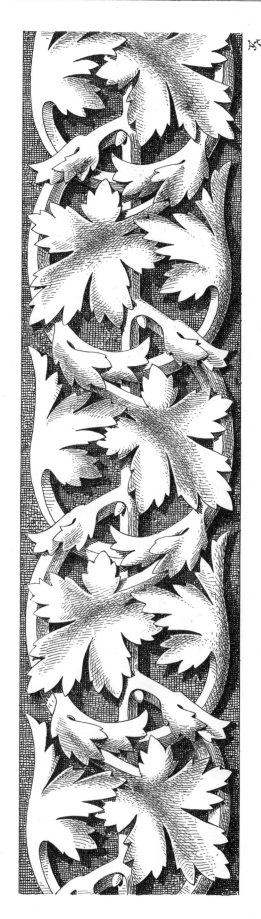

ENRICHED FRIEZES.

Plate 24

CARVED VOUSSOIRS,
AND DOUBLE SPANDRIL.

Plate 25

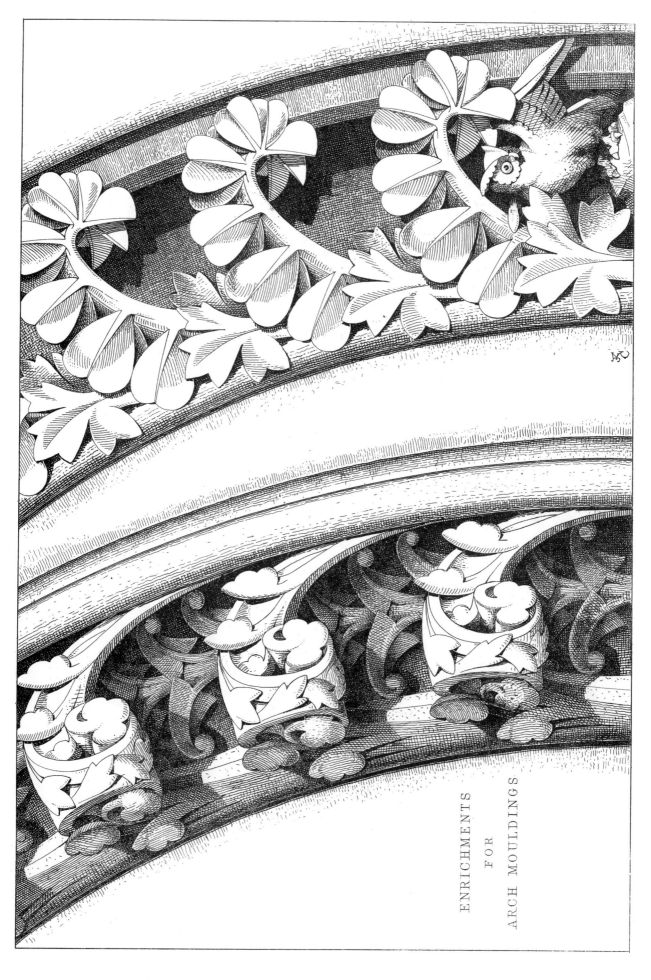

Plate 26

ENRICHMENTS
FOR
ARCH MOULDINGS

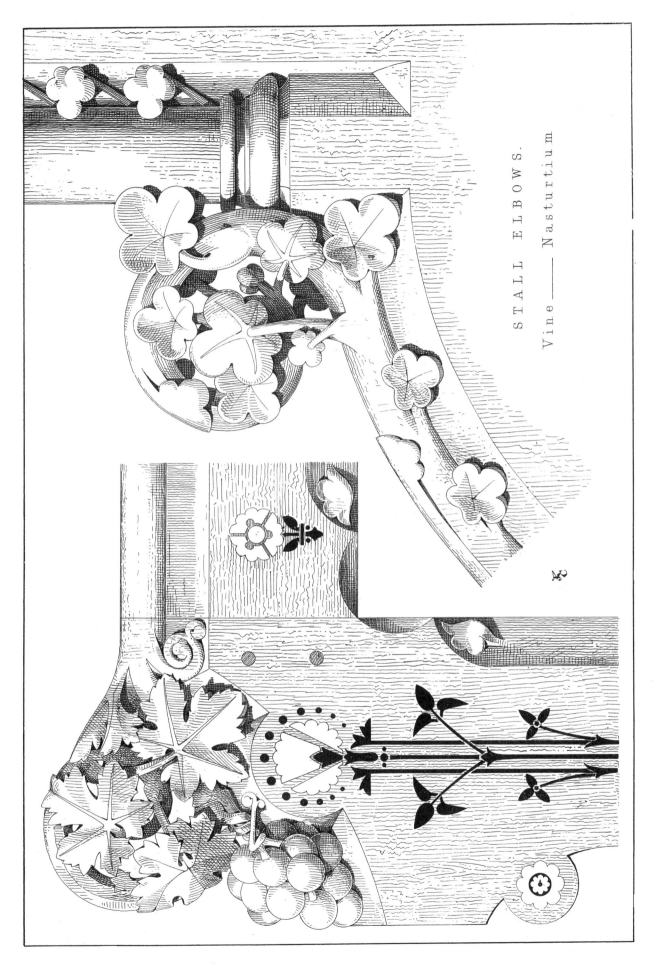

STALL ELBOWS.

Vine —— Nasturtium

Plate 27

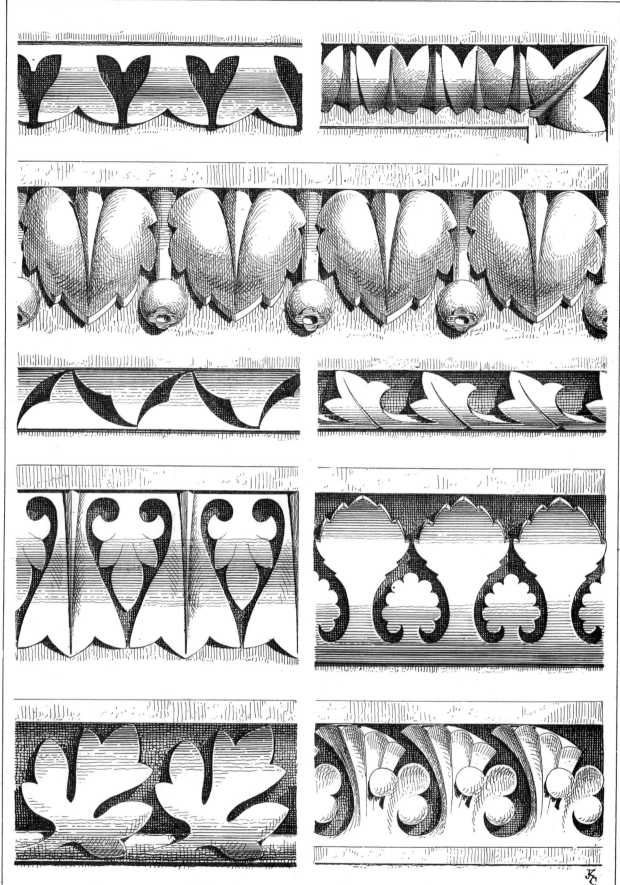

CLASSIC MOULDINGS.

Plate 28

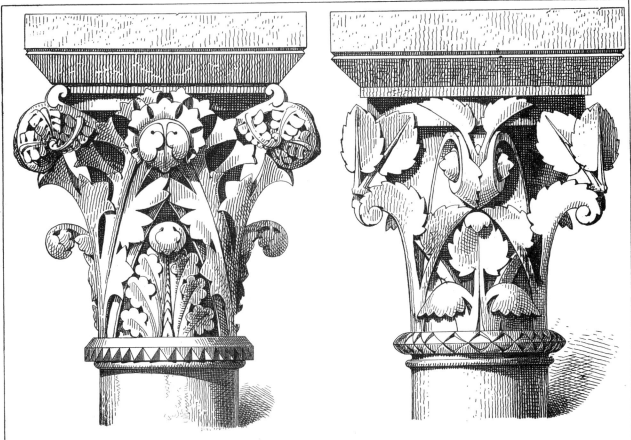

STONE CAPITALS

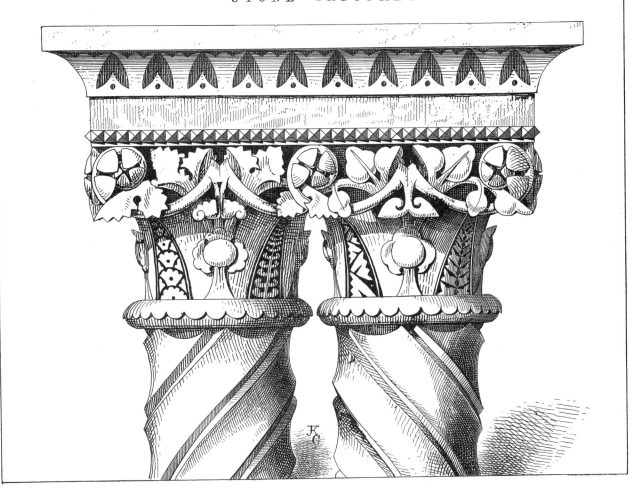

Plate 29

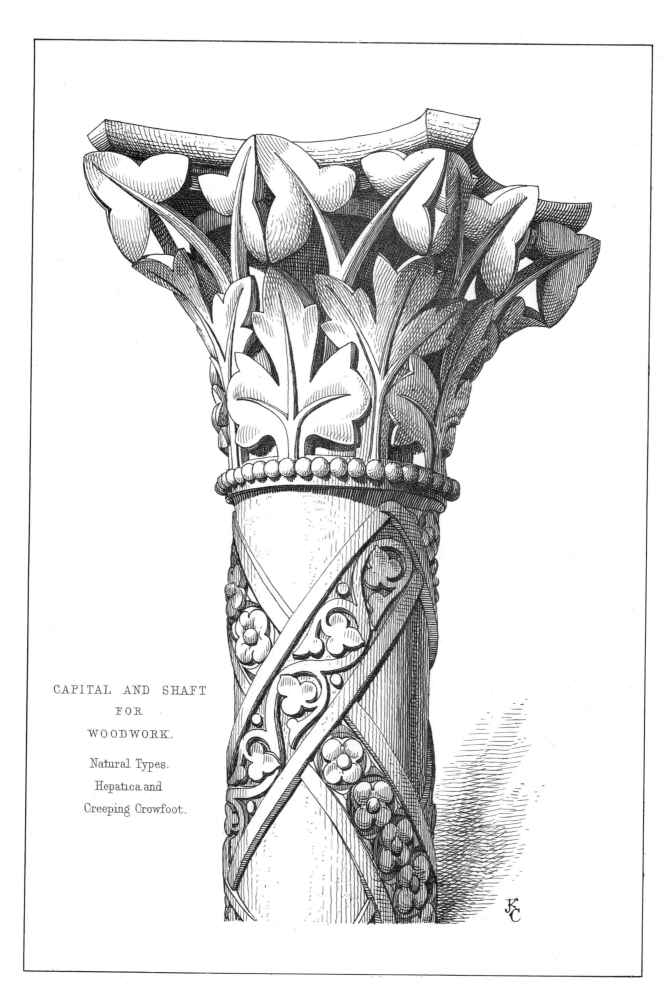

CAPITAL AND SHAFT
FOR
WOODWORK.

Natural Types.
Hepatica and
Creeping Crowfoot.

Plate 30

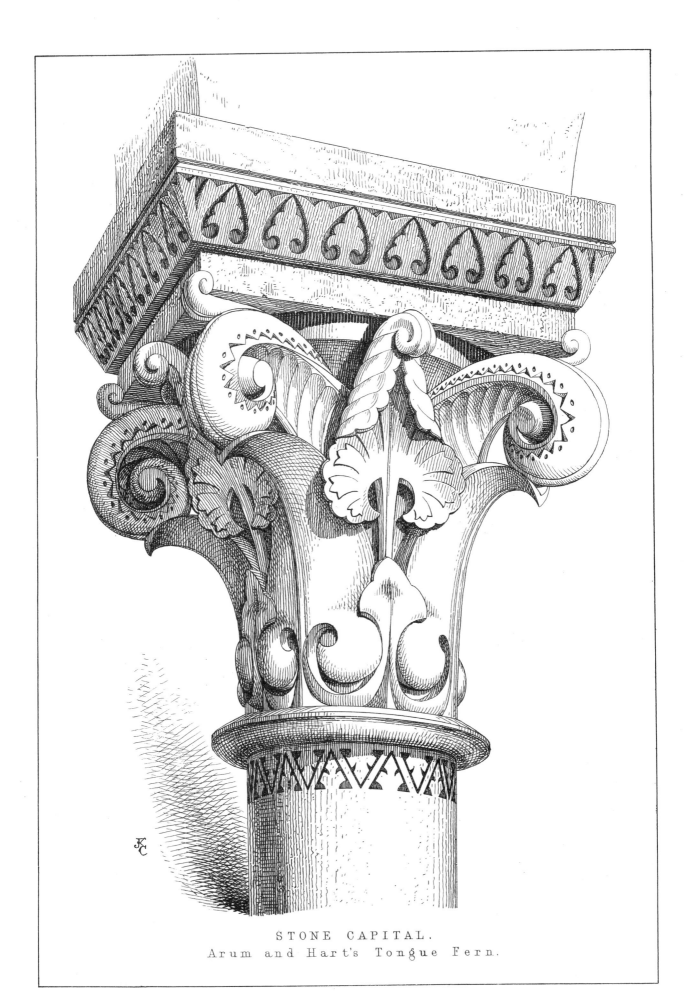

STONE CAPITAL.
Arum and Hart's Tongue Fern.

Plate 31

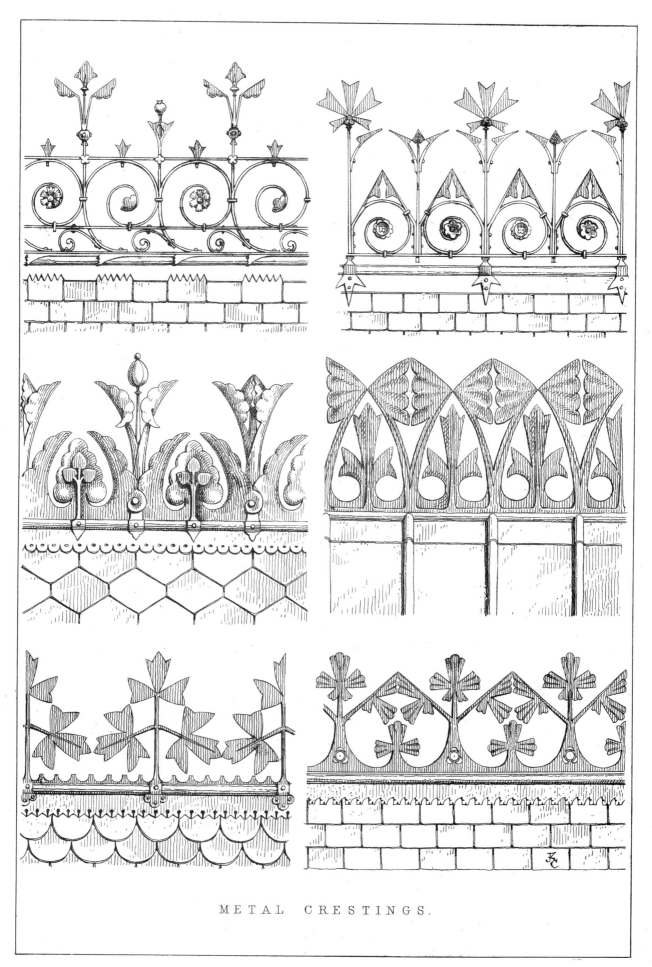

METAL CRESTINGS.

Plate 32

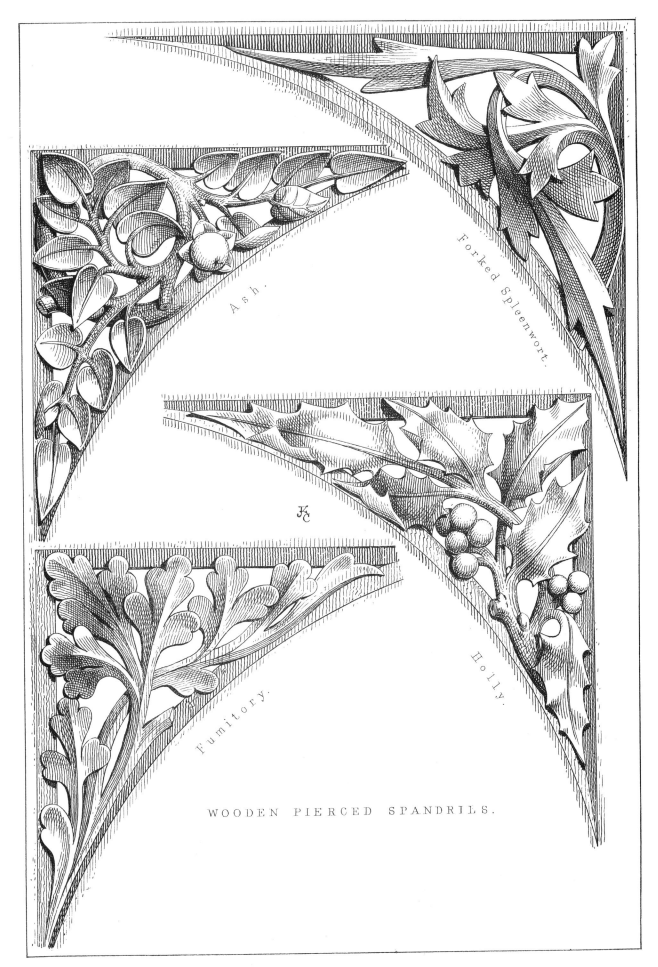

Forked Spleenwort.

Ash.

Holly.

Fumitory.

WOODEN PIERCED SPANDRILS.

Plate 33

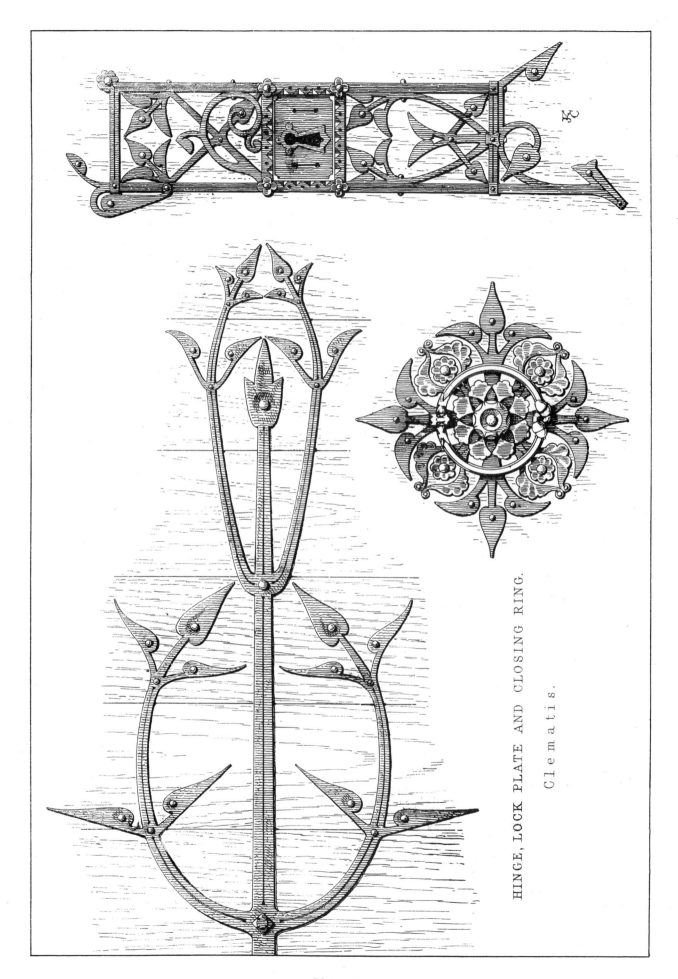

HINGE, LOCK PLATE AND CLOSING RING.

Clematis.

Plate 34

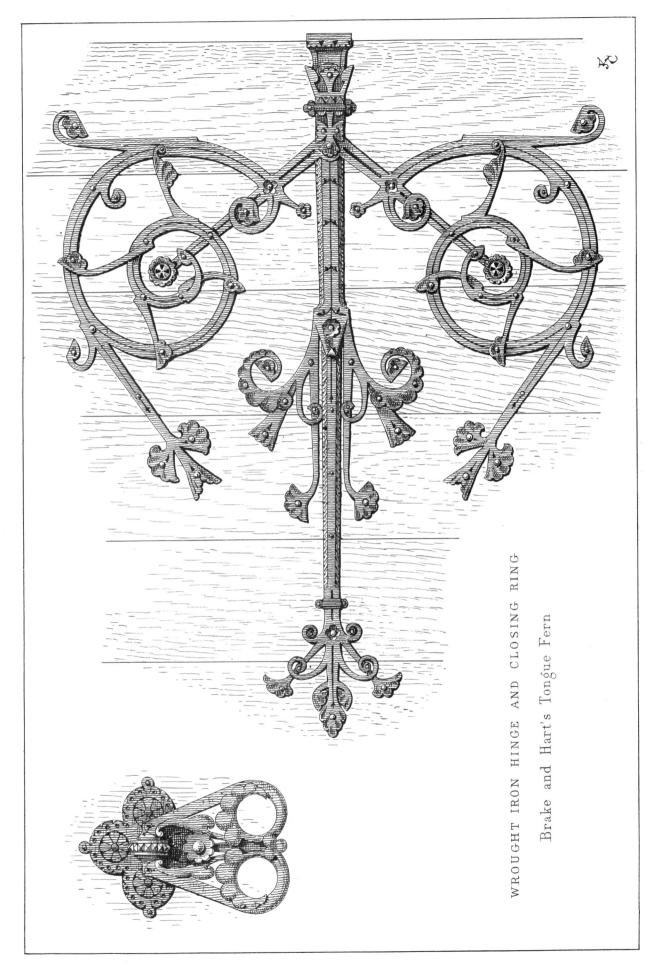

WROUGHT IRON HINGE AND CLOSING RING

Brake and Hart's Tongue Fern

Plate 35

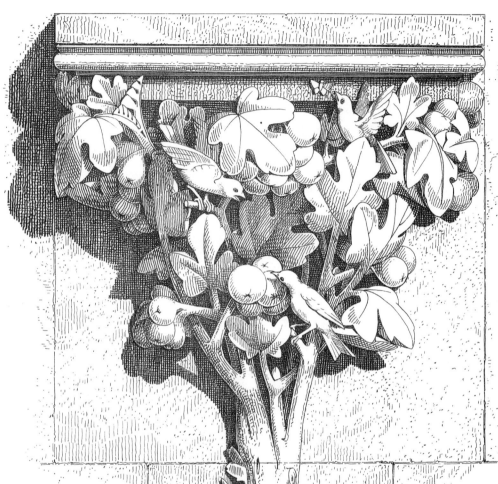

Fig
and
Lily.

"Every good tree
bringeth forth
good fruit."

STONE CORBEL.

Plate 36

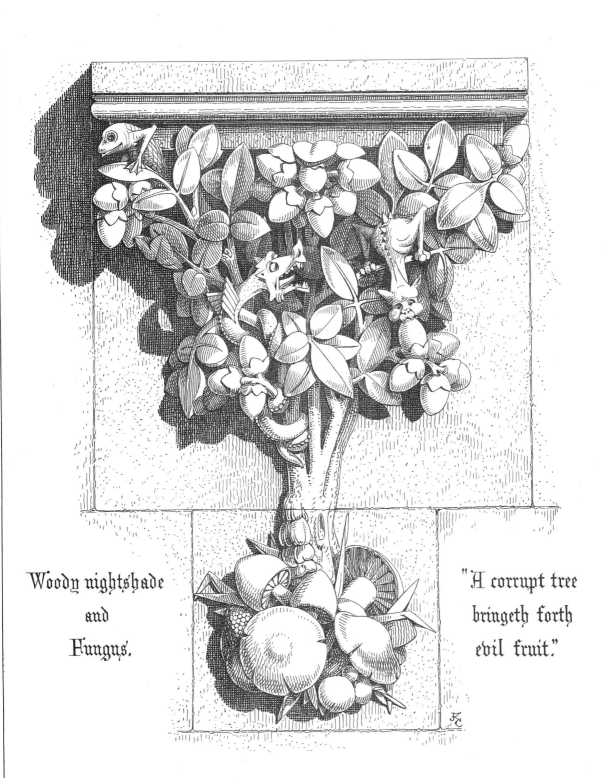

Woody nightshade
and
Fungus.

"A corrupt tree
bringeth forth
evil fruit."

STONE CORBEL.

Plate 37

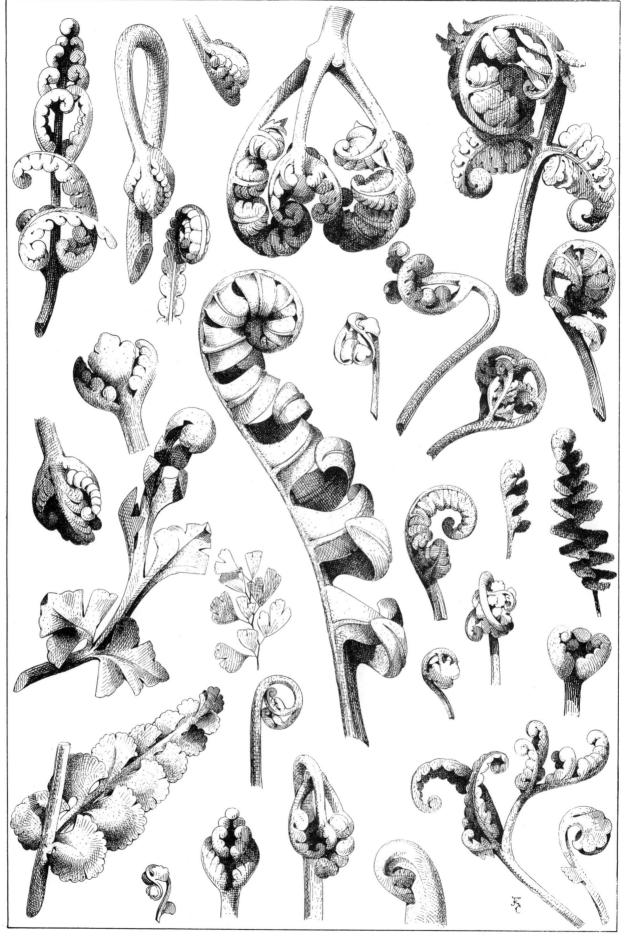

Plate 38

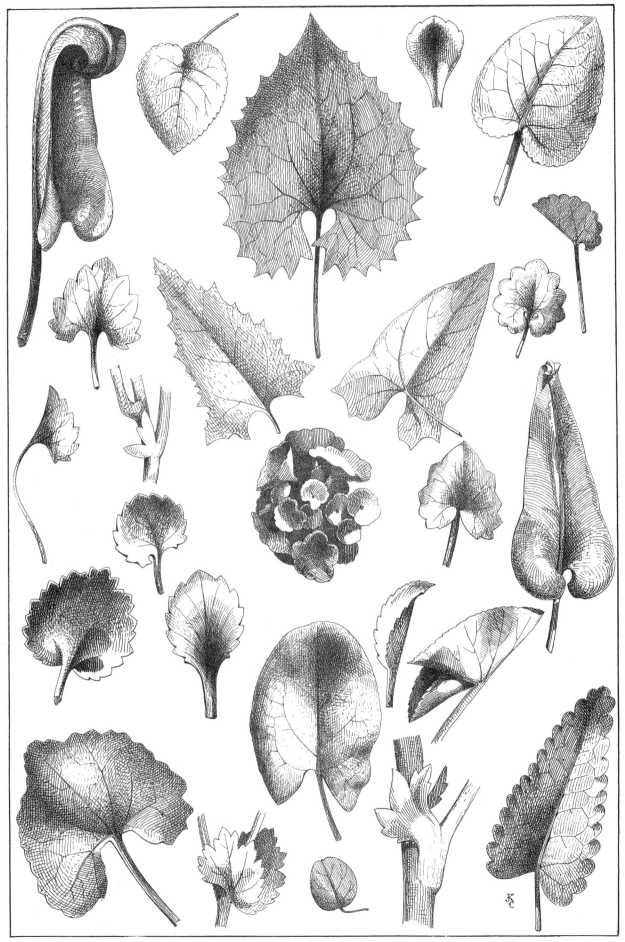

Plate 39

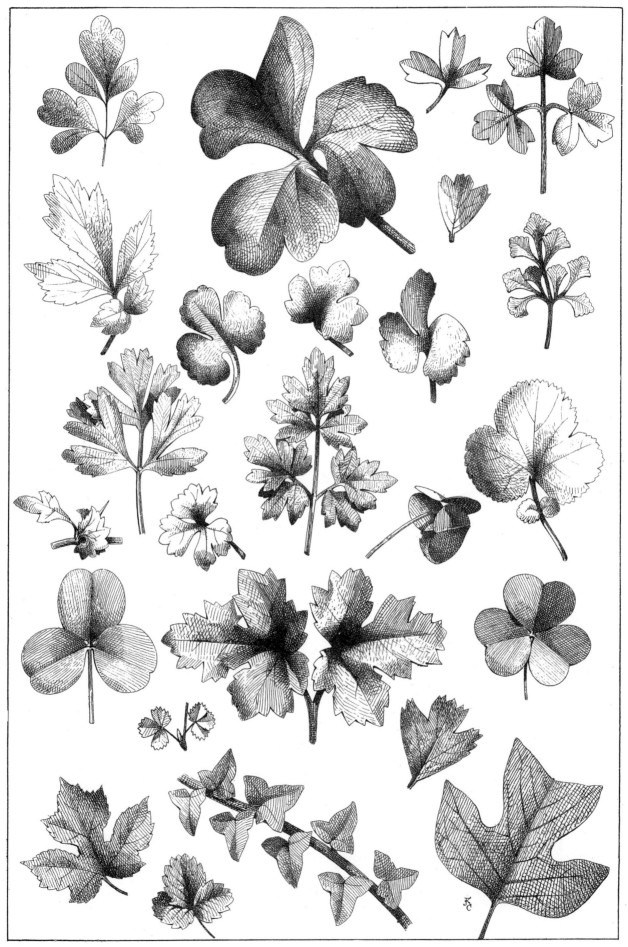

Plate 40

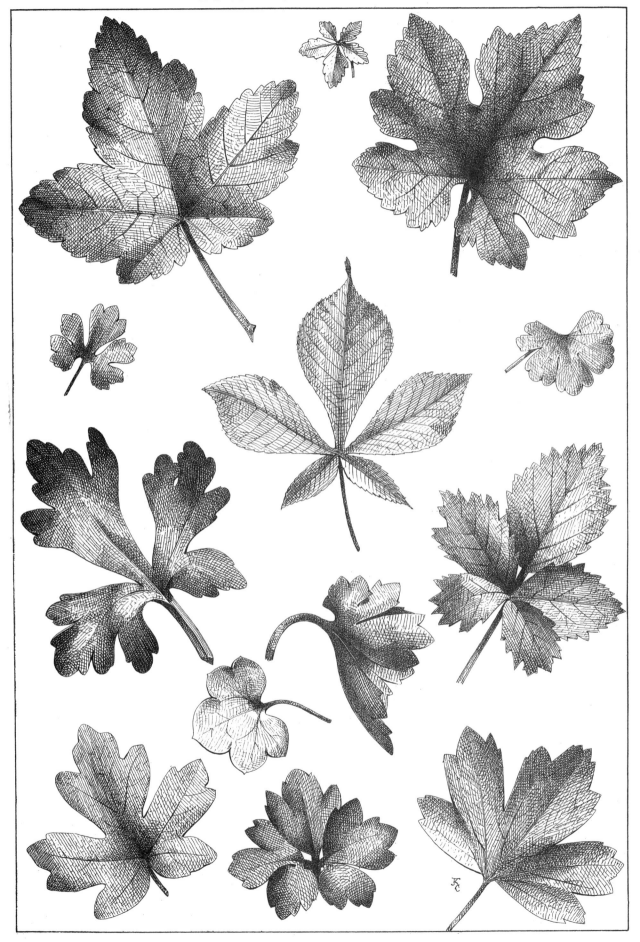

Plate 41

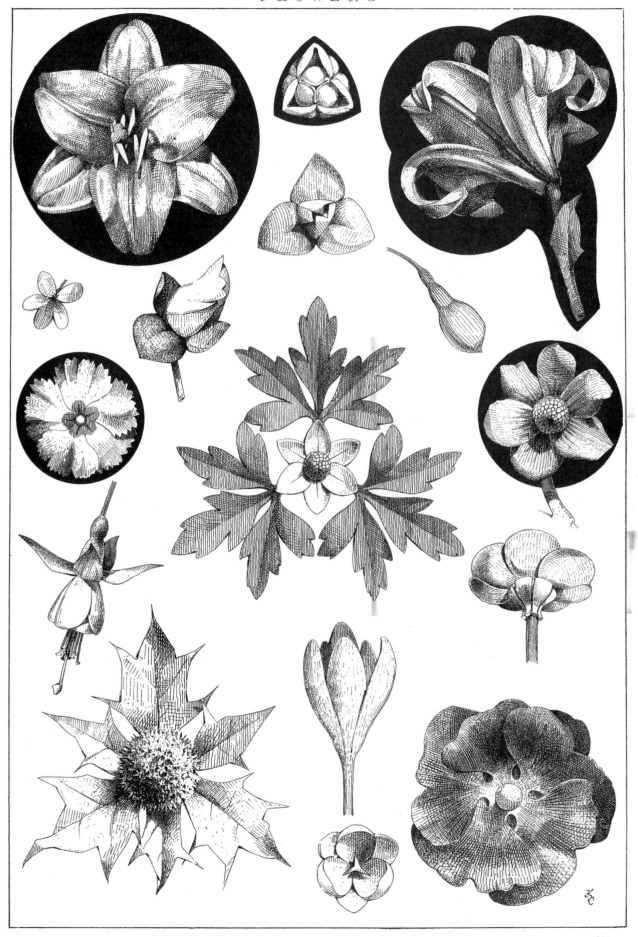

Plate 42

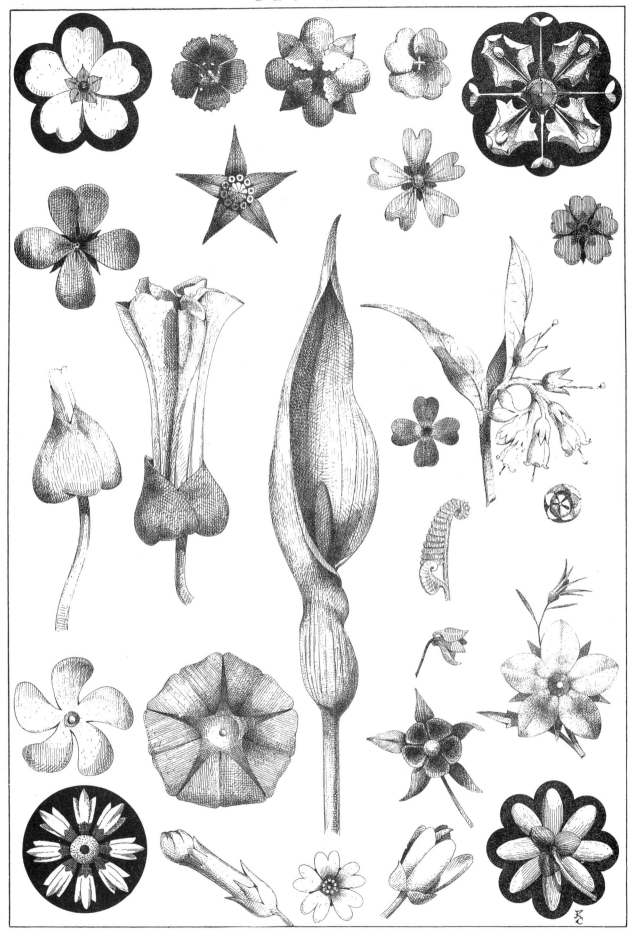

Plate 43

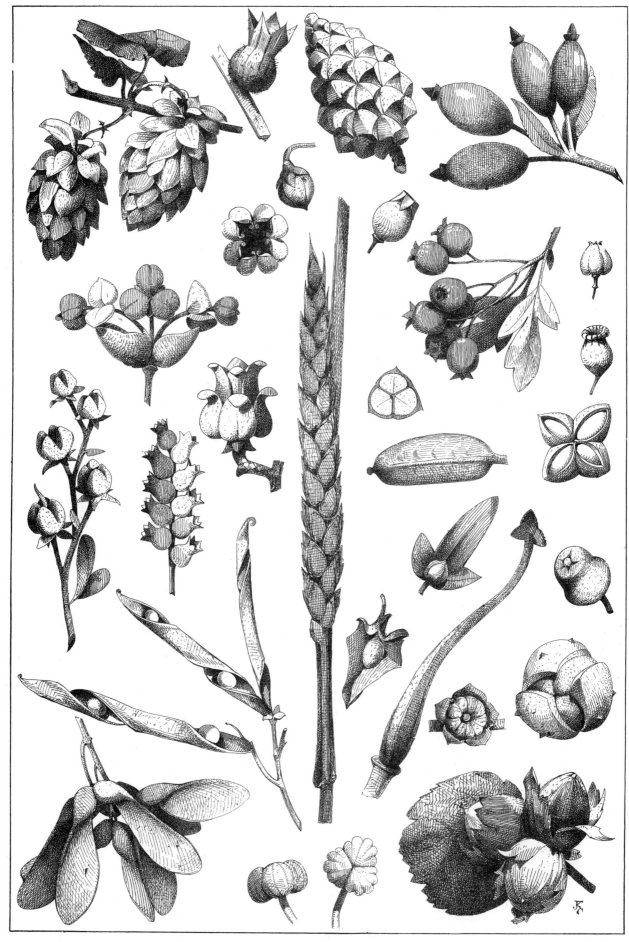

Plate 44